COLOUR
QUEST

Reveal the 30 stunning pictures in this book by following the colour codes.

Don't worry if you don't have pens or pencils that exactly match the colour key on the left-hand edge of each picture. Darker colours can be achieved by applying more pressure with a pencil, and lighter hues by pressing gently. With pens you can create darker shades by layering the ink. You can also create new, unique colours by blending two shades together. You don't even have to use the colours suggested and can choose your own palette. On some of the pages you will notice blank shapes without numbers inside. These should be left white.

There is a small, finished version of each image at the back of the book, just in case you can't wait to find out what you are colouring in.

Visit **www.mombooks.com/activities** to see larger solutions for each puzzle.

Michael O'Mara Books Limited

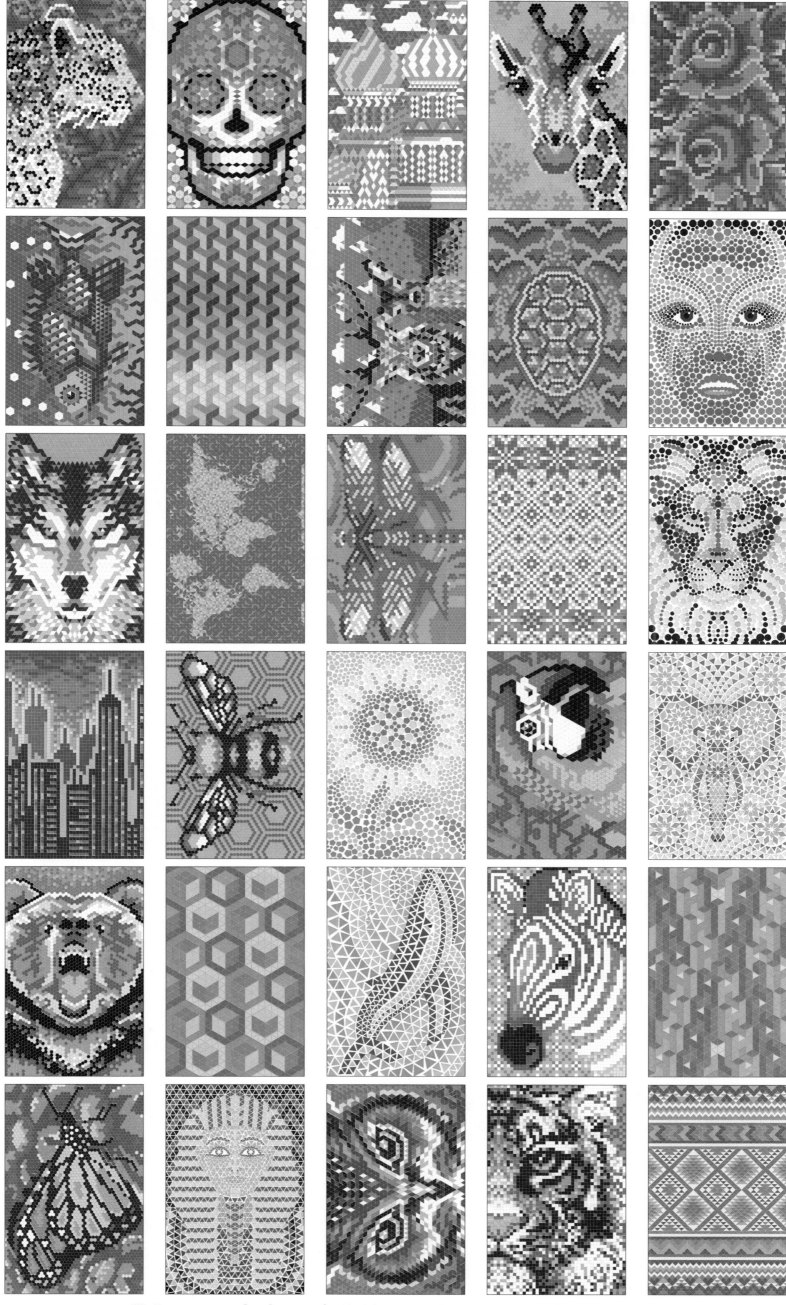